Praise for *Borealis*

"An extraordinary experience! The place *Bor...* lodged within a vivid consciousness. Here, th.......onment is populated by memories of lovers and strangers with guns. Letters from prison arrive in this place, and confinement haunts its wide margins. The soundtrack fades in and out, art is found and made. A landscape has never felt so real to me, so like life." —Eula Biss

"As aurora to her titular borealis, Aisha Sabatini Sloan bends and flashes with belletristic dexterity and a quietly big-sticked insistence upon her own agency. 'I forget what's a thing to say,' she writes, even as her unique geometries of syntax, set against the book's glacial blocks of white space, elicit revelatory ways not just to say a thing but to see it. Through dexterous collaging of art, literature, correspondence, music, overheards, skylight colors, and intellectual flexes set against a prison's visiting-room wall, *Borealis* resists bindings of genre or collective propinquity. Instead, Sabatini Sloan's conversational architectures of space illuminate landscape as an internal experience whose vastness, she finds, forces her to become her own friend." —Samiya Bashir

Praise for *Dreaming of Ramadi in Detroit*

Winner of the 2018 CLMP Firecracker Award for Creative Nonfiction
***The Rumpus*, "What to Read When You Want to Celebrate Pride"**

"Though it's hard to narrow down my choices in nonfiction, I can tell you that I put down Aisha Sabatini Sloan's *Dreaming of Ramadi in Detroit* and instantly wanted to pick it up again. The intelligence and expansiveness of this book of essays astounded me."
 —Camille Dungy

BOREALIS

BOREALIS

Aisha Sabatini Sloan

SPATIAL SPECIES SERIES

Youmna Chlala and Ken Chen, series editors

COFFEE HOUSE PRESS

Minneapolis
2021

Coffee House Press books are available to the trade through our
primary distributor, Consortium Book Sales & Distribution,
cbsd.com or (800) 283-3572. For personal orders, catalogs,
or other information, write to info@coffeehousepress.org.

Coffee House Press is a nonprofit literary publishing house.
Support from private foundations, corporate giving programs,
government programs, and generous individuals helps
make the publication of our books possible. We gratefully
acknowledge their support in detail in the back of this book.

LIBRARY OF CONGRESS CATALOGING-IN-PUBLICATION DATA

Names: Sabatini Sloan, Aisha, author.
Title: Borealis / Aisha Sabatini Sloan.
Description: Minneapolis : Coffee House Press, 2021.
Identifiers: LCCN 2021020992 (print) | LCCN 2021020993
 (ebook) | ISBN 9781566896191 (trade paperback) |
 ISBN 9781566896283 (epub)
Subjects: LCSH: Sabatini Sloan, Aisha. | Alaska. | LCGFT: Essays.
Classification: LCC PS3619.A265 B67 2021 (print) |
 LCC PS3619.A265 (ebook) | DDC 814/.6 [B]—dc23
LC record available at https://lccn.loc.gov/2021020992
LC ebook record available at https://lccn.loc.gov/2021020993

Printed in the United States of America

30 29 28 27 26 25 24 23 2 3 4 5 6 7 8 9

For Remy, a.k.a. Rio

Foreword

Dear Aisha,

As I read *Borealis,* Homer, Alaska, became a constellation of
relations finding their way toward each other over and over
again. Your way of looking is curious and alert. It is defiant
and humorous. It is also beautifully disorienting. As we try
to locate ourselves, spaces shape-shift. We inhabit moun-
tains, shorelines, tents, prisons, and cabins. It is as if you
are trying to land your gaze somewhere, but the landscape
won't let you.

You align your spatial movements with memory, art, and
associations. Some exchanges are intimate—with your
father, nephew, uncle, and wife. Some are distant, relation-
ships that have brought you to Homer before. This time, it
feels as if the landscape is your other. You revisit ocean,
shore, rock, cloud, sky, moon, driftwood, glacier, and moun-
tain. We encounter sea otters, seals, moose, dogs, birds,
whales, and bears. These sites and beings become entangled
in the connections. And there are many artists, writers,
filmmakers, and musicians who take part in the dispersed

conversation. Among them, Renee Gladman, Paul Simon, Björk, Adrian Piper, John Keene, Fred Moten, Maxine Hong Kingston, Robin Coste Lewis, and Saidiya Hartman.

Lorna Simpson's *Ice* painting series is there throughout. Her glaciers and worlds appear and disappear. The paintings question representation, they offer speculation, and sometimes they even fail. You write: *I'm feeling territorial about glaciers today.* The glacier is a real and imagined site of questions about the affects of place, seeing, and belonging. Because your seeing is multiple, it takes notice of beauty and terror. You write: *I'm working on this bright pile of a salad, quivering with angel hair–thin beets, and I'm eyeing the dock, unsure if the armed teen is off to shoot fucking wolf pups or what.*

Being alone in Homer, Alaska, is also about the fears, violence, and realities of being a visible, raced, gendered, and queer body. You write: *When there is no Black figure, what am I supposed to like looking at?* What happens when there is no reflection in the landscape? Not even refraction? What do we look for to make sense of where we are? The spaces you look at are simultaneously open and closed.

We begin to hear your boredom. We move through isolation and repetition. You illuminate the many forms of confinement and their consequences. We feel your unexpected losses. We're convinced no one will remember you've been there before. And then the waitress recognizes you. How do we look and heal? You write: *I figured I would never go to the chiropractor again because of the history of White supremacy and necks.* And then you do.

I imagine you pulling apart the fragments of memory, image, and encounter as you create a new system of seeing. This happens when you describe one of your own collages: *Fire-inflected circle, horizon line on the vertical. A woman with pink hair bending over. Our strangeness an attempt to smash back into the natural world.* With you, we remake the spaces within us into connections larger than ourselves.

Youmna Chlala, series editor

BOREALIS

Driving from Anchorage to Homer takes just over four hours. As I arrive, I am listening to an episode of *This American Life* in which Jelani Cobb talks about the activists from Ferguson who have died mysterious, violent deaths. This listening overlays the coastline—and the ice-covered mountains now visible across the pristine bay—with burning cars. A woman speaks of death threats while I drive past a sign that says "Welcome to Homer." Shaggy, off the side of the road, that's a moose. Where exactly have I driven myself?

In a gray journal I've jotted down, "Go back / re-create a space you can't return to."

On the plane ride over, two White men discussed the Illuminati loudly, a conspiracy about the left that the president has been retweeting. I was sitting across from them in the last row in front of the bathroom, and people pushed their bodies into my face while moving by with such pillow-like ferocity, such sparse apology, it was best to pretend it wasn't happening. It was like something Marina Abramović might ask people to do to her.

1

My first night in Homer, I dream there are flashlights beaming into the windows of the tiny house. My dream self tries to call my Airbnb hosts, then slinks down from the loft to see out the window that there are small monkeys, who are also the cast of a show I can't quite recall—I take pictures of them. A student recently explained that you are only allowed to write about dreams once in your writing life. I blurted back, "That's for fiction."

This manuscript has become a grid of small, white rect-angles on my kitchen table. I've left space between some of the rectangles, and now I'm making collages to better visualize what those spaces might be for. Some might call this procrastination. I've cut around the billow of a pink explosion and layered it on top of a gray square. There is a jolt of blue alongside an oval made of cotton candy–hued beach sand.

In Homer, I drive down the spit, a stretch of land that curves like a sloppy spiral jetty into the bay, covered in bald eagles. I drive slowly, remembering the play I once saw in a red playhouse called *The Electric Kool-Aid Antacid Test*. It was like watching Christopher Guest: LIVE. There is an almost carnivalesque area with a disintegrating ship and piles of colorful ship stuff. Docks reach out into the bay. Long stretches of rocky beach, then sandy beach. Then, two rows of shops facing each other. A ferry terminal. A huge Chinese restaurant. You can buy art and candy and indigenous halibut hooks.

I have spent three summers here with women I've dated, without access, or much access, to a car. I marvel at how many miles we walked or biked to get to a tent or a cabin with no running water. Now, I drive a compact rental car and stay in a tiny house that has been decorated with, I imagine, the guidance of Chip and Joanna Gaines. The floors are that gray-brown wood popularized by HGTV. There is a sconce with fake flowers. There is a small loft up a set of steep stairs. There is just enough room for a couch along the windows, punctuated by a small table. A heater that is meant to look old-timey lurks underneath the stairs. A bathroom beyond the kitchen with a bounty of clean, white towels. I lay copies of Lorna Simpson paintings on the couch like an altar.

All along the spit, Sinatra sings "When I Was Seventeen" on the car radio. It is a very slow song. Like an empty dance floor. It is lonely, and it supposes that thirty-five is the last point in this man's life he will ever feel young. I feel all of my ages now, imagining those selves walking or biking along the water's edge.

If I were going to choose a quotation to describe my relationship to this place, it would be this from Renee Gladman:

> *I began the day asking the individuals of this group of my ex-lovers to map a problem of space, but not the problem that involved the anxiety of whether they could or could not draw, nor the one that asked how it was even possible to translate "problems" into lines, rather, I meant real problems, where you had to think about where you were in a defined space and what your purpose was for being there.*

I asked out K, my college girlfriend, with a quote from the film *Crossing Delancey.* I crafted courtly emails in a rush of adrenaline to entertain my friends. On our first date we drank sweet, hot beverages at a quiet bar in our small midwestern town. Someone was wearing cowboy boots. It was me. After the first night at her co-op, I woke to go to the printmaking studio, high off of her, living out a scene from the movie I had and had not imagined for my life: rumpled sheets. Morning light in an empty art space.

After we graduated, she moved to Alaska. Lived through a rose- and slate-skied winter with her best friend in a cabin with no running water. She had a day job assisting a dog musher. We were on again, off again when she got a dog and named him after a tropical bird.

I moved home to California and had panic attacks looping the golf course where, sometimes, I might jog past Dustin Hoffman. I looked at the ocean a lot and worked at a bookstore in a mall and cried constantly in the self-help section. I had boarded a flight from Montana to Los Angeles when suddenly I got the idea to get off the plane and buy a ticket to Alaska.

I kept unbuckling my seat belt, thinking I would march down the gangplank, go up to the counter, and fly to Fairbanks. It

was the middle of winter. I had no coat. The thin White man next to me turned, slowly, and asked if I was O.K. I kept rising to disembark. For some reason, I told him everything. He listened calmly and suggested my relationship with K was not contingent on me flying to Alaska on a whim.

I flew back to my parents' apartment. I thought I might be a nanny in France and was saving money without making any plans. One day, after hearing a friend's roommate had moved out, I asked my manager if I could transfer to another bookstore and moved, on a whim, to Boston. When K invited me to spend the summer with her in Homer, we had been on a long pause. It was a gorgeous depression of a winter. I walked to the bookstore. Modeled with my clothes on for a drawing class near the Alewife stop at the end of the Red Line. Saw *Eternal Sunshine of the Spotless Mind* in the theater. I was sleeping with a coworker who had freckles and the most delicious gap in her teeth.

In Anne Carson's "Kinds of Water," the speaker describes a pilgrimage along the road to Compostela. She writes about a river underneath her hotel window with a big waterfall. "There is a dark shape at the edge of the falls, as I look down, knocking this way and that in the force of the current. It would seem to be a drowned dog. It *is* a drowned dog." She goes back and forth about it. "Could there be a sculpture of a drowned dog on the ledge of an ancient waterfall?"

The first time I read this passage, I felt quite positive it was about the time when I sat with K at a restaurant alongside a river in Fairbanks. There was no dead dog. The memory has a pleasant feeling—the gray sluice of water below, a strange trip so far into nowhere. It must be the sensation of coming to an edge and looking over.

A fragment of an afternoon from that time: We took a walk from a friend's cabin toward an intersection. I remember feeling the degree to which we were inland like barometric pressure, a sensation at my sides. We were surrounded by a nostalgic version of the colors pink and green and yellow and light brown. Like experiencing summer for the first time. A character in a TV show is named Prairie, and I keep imagining something about her is relevant here.

We crossed a bridge between Homer and Fairbanks where, my girlfriend told me, trucks had been knocked over by the wind. There was a moment, in what I recall as silver light, when I seemed to say to myself, *Alaska! Alaska!* There must have been moon then. We stood next to a car on the edge of a road between cities. Like eclipse, it would have been an off glow. The dog named after a tropical bird would one day die on the night of a total eclipse. A short-legged, black baby with ears like an art teacher's haircut, who scream-sang at squirrels.

Carson writes, "The moon makes a traveler hunger for something bitter in the world, what is it? I will vanish; others will come here, what is that? An old question."

Lorna Simpson has been painting glaciers. Human-sized, cataclysmic. Eviscerated ice overlaid by a deep blue wash. Tumbling ash, full spectrum of gray. Volcanic clouds. Nothing whatsoever warm. I have long loved her photography, which is often paired with text and has an archival feel—bodies of evidence laid out with numerical precision, like slides on a light box, clinical amid a world of white space. Whereas these paintings gut. They are unfurling and torn open. A wound before the blood comes. A *Vogue* article explains: "Nature hasn't looked this turbulent in a painting since J.M.W. Turner."

According to my father, the ghost of J. M. W. Turner used to visit Gordon Parks. The dead painter sat on the edge of the dying photographer's bed and told him stories. Parks was writing a novel about Turner at the time called *The Sun Stalker.*

Robin Coste Lewis uses the titles of paintings to create poems refracting the meaning of Black womanhood in her book *Voyage of the Sable Venus.*

In class I assign students to mimic her approach, harvesting language from the titles of art. In my notebook I reassemble words from paintings by J. M. W. Turner and call it an explanation for his appeal among Black artists:

The Battle of Light and Color.
The Decline of the Burning of the Modern.
The Shipwreck of Moses Rising through Vapour.
The Fighting Peace.
The Burial of Becalmed Heaving.
His Mouth, the Fighting.
Porch of the Deluge.
Crossing the Alps of Empire.
Rain, Slave, and Speed.

I first heard about Matthew Henson when an art professor showed us a sneak peek of the video project "True North," created by the conceptual artist Isaac Julien. Inspired by Julien's stark photographs of Black skin against blue-white snow, I wrote about Matthew Henson's journey to Antarctica in a letter to my nephew, who had recently been put into solitary confinement.

Something in me positioned the prison cell against the glacier, an immediate and insistent binary. I was newly discovering meditation and interwove the letter with stories from the Anapanasati Sutta about the Buddha's awakening. I wanted to give my nephew [proselytize] the sensation of space. The glacier made me feel as if I were on the very edge of the planet. One time, I called it "a jewel that adorned my quiet life." As if freedom of movement could be crystallized, cut, and set into a ring. But ice is a lock. A container of suspended time.

During a conversation with Fred Moten about "the Black outdoors," Saidiya Hartman talks about the effort to "produce a thought of the outside while in the inside." She speaks of "trying to produce an outside, trying to create an opening."

After watching the movie *Hancock,* in which Will Smith sketches his life as a Greek god into the walls of his jail cell, I write in the letter to my nephew, "I picture you on the floor of such a place, legs crossed beneath you, breath like an instrument enacting space and time into the surface of the cell." I quote a book by Jeri Ferris: When Matthew Henson first traveled to Iceland, he "saw glaciers that looked like thick, flowing cream, frozen into white walls." I imagined projecting photographs of a frozen landscape taken from above onto the corner of a room.

"I don't really sit on the floor," he wrote back.

I read my nephew's first letter from solitary confinement while I was on a plane between Tucson and Detroit. I have this memory of pacing the aisle, taking pictures of the landscape to send him. I wrote, "It seems impossible for the ground to be as red as it is—like cranberry juice or blood pooling in the cupped hands of a dust-brown valley."

I have cut up a photograph of a falcon and placed it underneath an upside-down wildfire. There is a saguaro in the snow, fragments of a numerical equation.

For months I have been sitting on my nephew's most recent mailing, a collection of essays he has written over the last few years.

In the first, entitled "Degrees," he writes, "How can I calm the waters? Give me the recipe to the remedy to a wildfire that stretches way beyond Cali. Set ablaze by society, instigated our temperaments then ask why as an inside joke. A countdown behind our backs, they just waiting on us to blow. On standby for our demise, and I'm just falling into the trap, watching myself slip, don't wanna lose my freedom, but don't wanna lose my sanity either. What's one without the other? Damn that's like a car with no brakes, a climate with no rain, or snow all year round."

He writes, "Alaska being my only state of mind."

A man I first saw during my lonely winter in Boston announcing his queerness to a conference room full of polite coughing told me Lorna Simpson was collaborating with Robin Coste Lewis on new work. I went home and watched the two women stand on the stage, sequentially, at a venue about Blackness in Pittsburgh.

What came next was a series called *Darkening*. In one painting, *Specific Notation*, Doreen St. Félix writes, "the head of a woman" is "frozen in the icy blue canvas, she seems eternal, outside of time." The series was inspired by Robin Coste Lewis's poem "Using Black to Paint Light: Walking through a Matisse Exhibit, Thinking about the Arctic and Matthew Henson."

Lewis writes, "I wonder, Matthew, when you were out on the ice for years, trying very hard not to fall through, I wonder whether—like me—you ever thought of the same woman over and over again."

I keep finding notes about glaciers in variously sized gray notebooks. I was just outside of Pittsburgh, at a venue not about Blackness, when I wrote, "A thing meant to expand all the way to the ends of the earth becomes a growth, a helmet, another strangeness you can carry around with you. 'What is this? This is where I go.'"

As I walk away from the beach, on a grated walkway, I see an RV painted with the word "wohre," along with a bungled swastika in fading, orange sherbet-colored spray paint. *I am alone in Alaska,* I keep telling myself. This is not the only kind of detail that is important to notice about a place. Perhaps the problem is that for the first time, nobody but my Airbnb host has a claim on me here. I am a loose body with no clear purpose.

At the beach I try not to read the bumper stickers in the parking lot. I glance at the woman in the car covered with flags without letting my eyes land long enough to meet hers. Everywhere there are people with beliefs. Russia is so close to here. When Sarah Palin said it, well, you remember that. But I dare you to go to Alaska and look at a map without saying something equally inane. In our minds, which are collapsing, Russia can't possibly be this close. And by Russia, I mean a lot of things.

Matthew Henson described his third arctic winter as full of "gorgeous bleakness, beautiful blackness." The only light came from the moon, which "made a fairyland of the dark valleys, glistening snow and deep, deep silence."

The first day I began to think of my wife romantically, I was at the Tucson dump with a mutual friend, depositing old furniture for my mentor, who had recently lost her husband. "Do you want these?" she asked, handing over a Ziploc bag of frozen pot cookies, and so the mutual friend and I found ourselves doing a photo shoot in lawn furniture near piles of garbage. The sky was vibrant, and the trash lit up like a stage set. It was at this time that our mutual friend said to me of my future wife, "She's single," setting the whole thing into motion. Later, I bought a stone at a store called Metaphysical World and held on to it like a buddy during the "no talking" portion of a meditation retreat. A family of javelina roamed the property, tiny tusked, in a line.

I listen to one of my favorite directors on the podcast *The Treatment* while driving up a mountain. I am calmed by the sound of a Black man and a White French woman complaining about capitalism while I encounter those first sharp curves in the road.

My friend used to live in a room in a blue house on this mountain, or something was blue. I keep straining at my memory, which seems to have weakened over time, like the muscles in my back. This friend walked up the mountain to go home one day, in that dull middle-of-the-night light, and encountered dogs. She and I would sing a song about Scottish independence by the Proclaimers over and over. These facts once took up so much space in my head.

Claire Denis's new film is not about French colonialism in Africa; it is about outer space in the near future. To explain the title, she recalls the way some musicians once joked about how White people approximate joy.

All of this is discussed as I move through a particular landscape: green ground cover that will burst into purple flowers once I have gone. Elvis says he is having one of the best conversations of his life.

In the bigger of my two gray notebooks, I have written down a page number with no book title and the quote "Long hours spent in the study of any text will reveal inner, unseen contours, an abstract architecture." I go to the shelf, open to page 281 of John Keene's *Counternarratives,* and find the quote nestled in a story that, as I was reading, seemed to be voiced by a lion or tiger.

"What is meaningful about the fact that your notebooks are gray?" my editor wonders. I think the answer is that gray is the closest any of my journals come to the color of ice. I page through the sexy A4 and her sister [a marbled B5 with thicker-than-feels-necessary lines] in an act of bibliomancy: directions from the glacier herself.

When I said I would join her in Homer after she found a mix-tape of Billie Holiday and began to miss me, K got us a cabin halfway up a mountain and bought a gray station wagon. She taught me how to drive a stick shift in the parking lot of a middle school where, I want to say, there were whale skeletons hanging from the ceiling. The dog named after a tropical bird lived with us in a cabin with a lofted second story, no running water, and an outhouse. The upstairs was blasted with bright white light, and once, K stood in front of the window naked, her strong, white back backlit, a caterpillar scar on her shoulder. I read *Dykes to Watch Out For* all day like I was binge-watching TV. Every outhouse I've been to in Alaska has a crescent moon carved into the door. Whenever we went to a house with plumbing, I excused myself, found the bathroom, and snuck a shower.

I got a job at a bookstore and coasted down a hill on my bike. At night we would drink at Alice's Champagne Palace. Something happened involving a fisherman and a past life, I can't explain it. We went to parties and smoked weed on a famous singer's family ranch [her name is not *not* a stone] and drank from growlers. Alaskans were like my girlfriend, prepared for discomfort, easy to smile. Dressed like geology majors. A bunch of lesbians had spotted her when she first came to town and adopted her into their girl gang. We did

our laundry at the Washboard. K helped build the new oven at a bakery. We were always on somebody's porch. It was my first living room full of green-eyed lesbian firefighters, the first time I saw queerness has a kind of architecture, a tallness, if a White one.

People would come to the bookstore and call me by the wrong name, always the same wrong name. One day, I walked into a mirror. *So you're the other mixed girl,* we told ourselves.

I'm feeling territorial about glaciers today. The drip in one of Simpson's images feels dramatic compared with what I see across the bay. Like a soap opera painting of a glacier. My frustration with the dissonance is a kind of denial. When my future self brings this up with a massage therapist, he understands exactly what I mean.

Later, of this trip, I will write, "The phasing into and out of boredom and terror. How to watch while being watched."

Last year around this time, I saw the Adrian Piper retrospective at the MOMA. I had never before heard of her architectural plans for a giant grid: "At each hour of the day, from sunrise to sunset, the shadow image cast by the grid is in a different position and covers a different area." She writes, "Each passing minute puts them in a totally different position in time and space than the last."

There is something thrilling to me about a Black woman designing an intervention of a public space, directing how passersby are lit. Even if what she creates resembles a cage.

In *Calamities*, Renee Gladman writes, "I was going to draw a grid of light." While discussing this quotation with a group of artists via Skype, one woman pointed out that I was sitting underneath a grid.

Perhaps because I am looking at the glacier through Lorna Simpson's paintings, it becomes less of an entity than an idea, a design, a set of intersecting planes.

My own experience here is one of long shards of time. Because I cannot kill it, I traverse my boredom. The road keeps extending. I park the car and walk for miles.

I begin to think of boredom as a glacier, a cactus flower that blossoms from your mind, inside of which you can look at the world, a lighthouse, a vantage point, a zone of safety.

I've cut out a rectangle of green metal, yellow fabric, the negative space that once surrounded the oval beach. Some glowing magenta jellyfish legs and a fragment of the letter *M*. A collage in the grid of this book acts, for me, as a kind of window.

In a letter, I told my nephew about going to see a performance by the Garth Fagan Dance troupe: "The black body of a man about your age shot into the air, his muscles ripped into profound relief. For the first time, like caught breath, I understood the confinement being imposed upon you, and when I say that I began to cry, what I mean is that this was the beginning of our adult relationship."

The first time I visited him in prison, the grounds were oddly bucolic. The jokester of a guard who greeted us reminded me of *The Andy Griffith Show.* When I ask him about this recently, my nephew explains, "That's because there were trees."

In Tucson, I got lost bringing a poet to speak at a prison. You had to drive through naked, glaring, brown-white desert to get to a threshold, wait for a series of gates to open. There were many guns. You then went with a man whose arm was the size of several animals in a truck. You had to empty your pockets, be willing to empty yourself. Then you had to drive through more desert before arriving at a building. And this was for the children. In a place like this, escape has an element of absurdity. You get a sunburn just exiting the car. How could anyone possibly move unseen through this

blankness, this box of dust and sun—considering water?
And shadows?

My nephew puts his hand in the air, as if imitating a shaft of
light. He recalls the time a man said to him, "I haven't seen
a tree in twenty years."

In another Lorna Simpson ice painting, the bakery—I'm sorry—the glacier, it slouches. It is a cotton swab of newspaper static. An angry butthole vortex cluster with multiple ears and mouths. Its peaks are timid, wasplike, ornamental. It has hacked into its tissue. Its eyes are leaking, her father shouts from the past. The desert encroaches. Is it that the blue is so pretty? A tumult of indigo. How majestic it all feels. So stylishly moody. There is a door in the corner.

On our first date, I walked into the Richard Serra sculpture *Band* and my wife was inside. *Did you feel that?* I asked, of the vertigo. Something happens to your body's sense of scale as you pass into the space between rust-colored curls of steel. Your brain thinks you're stepping up or down.

Another time, when I hit an impasse, my wife told me: turn.

Wendy S. Walters begins an essay by saying, "When I and whoever else was left of Black America finally got out of there, we met up in Norway."

Iceland is neither Norway nor Alaska, but there was a day not long ago when I gathered in Reykjavík with a group of Black women who were and were not Wendy, whom I had emailed from a cubicle.

One of us couldn't make it. She would have been the mapmaker, the one who makes drawings of a city that could easily be taken for a glacier. In one of her drawings, which I have on my desk now, stairs shaped like language move upward, toward areas of blue.

One of us took a photograph with her sister in front of a sign that said "Black Sand Beach," covering the *S*. I later did the same, like an echo or littler sister. When I first met her, she wore a fluorescent orange coat. She asked me to eat a piece of paper, and I did.

One of us moderated a panel in Minneapolis. I took pages of notes in my journal on the way she moved, the phrases she uttered. The audience rose up like zombies. One man

asked, "Can I touch you?" And the moderator's eyes flashed, sudden butterflies.

One of us walked through a museum and I moved parallel, tracking her laughter, listening for her footsteps in the room about Jerusalem.

One of us kept disappearing, appearing suddenly in a crowd.

My personality retracted in the presence of so much beauty in one place. I followed these women as we walked around and around a city block in Reykjavík. I traced with my eyes the way their selves moved beyond their bodies. We planned to take pictures of each other, fascinated by the visual of our Blackness against the backdrop of this place, which was a city, but beyond it, geysers, waterfalls, lagoons.

On the day we were meant to discuss our imaginations in public, I came down with something of a norovirus and vomited myself into the emergency room. The nurse did not believe anything I told her at first and asked me to walk from the doorway to the bed to prove my exhaustion while my wife stood by, astonished by the woman's callousness.

Lorna Simpson has a series of collages in which Black women's heads open into gemstones.

After Anne Carson, I've written a "short talk on glaciers": exhale colored mountain as the trajectory of an idea cracking. Natural hair is an idea of worth mined for resale. Hair as a way to visualize ideas, running rampant, old as time, unnoticed. Trampled, ivy, melting, bear-trodden, tree splintered, moaning, silent, aloud.

To give my days structure, I take walks along the spit or a busy road. I want to want a more intimate experience with nature but keep not turning down thinner trails, even ones that lead toward a potent memory, for fear of moose tramplings or men. Two dogs that look quite sweet begin to bark as I pass, unleashed and running, so I cross the road, now worried they will cross after me and get hit.

When I brought my dog, named for an author, not a bird, to Alaska, she ran and ran toward the ocean at low tide until she found the skull of a seal.

Fred Moten, speaking of the Black outdoors, talks of stopping off on a road trip to hike with his children. But "I could just always hear somebody running."

I listen to Björk's song "Hunter" as I move through town. She, along with Chance the Rapper, brings the landscape into a kind of alignment with my nervous system.

I put one of Lorna Simpson's ice paintings against the sky. In the real world, I see no blue clouds that rumble at the bottom of a melting, crumpling white. Unless you count the water, which is more like a mirror than a cloud because it's overcast. Maybe when the sun comes out it will look different. You have to look hard to see the glacier's quality—it scoops, spills itself, has a kind of frost-blue cool you have to discern from the white. A trick of the eye.

Recently, I found a book my nephew sent me years ago, called *The Value of Nothing*.

The sun finally comes out. Joanna Macy, on a podcast, is reciting Rilke. She says we don't get to choose whether or not this is the time we're living in, it's already here. She turns my head to the rust-colored water lining the side of East End Road, which I'd been unconsciously avoiding. It could be nothing bad, I have no idea, but sometimes it is bubbling, sometimes fizzy with moss, or slick black. Like someone poured oil and melted crayons and rust and dish soap into a trench.

One day, Macy walked into a bookstore in Germany and picked up a copy of *The Book of Hours*. She reads in German first, then translates: "I live my life in widening circles." She speaks of orbiting God in a way that makes me hear the word *god* differently, and I weep alongside the road. I once listened to this episode after a breakup. I sang "While My Guitar Gently Weeps" to myself. It is unfathomably soothing to let the word *why* erupt out of you until it takes up the space of an entire room. Also: *unfold.*

At a Q&A once, a student asked what I meant when I wrote about having cried. We handed sentences back and forth, two self-identified criers dialoging in a room full of unspecified others. The student's face seemed, even then, on the verge. Now I think crying is like touching time. A halfhearted attempt to crash into now.

I cut out a fragment of fire at night. I spend a long time slicing thin, blue lines, then glue them into a shape like reaching out, as if they are the visual representation of someone's voice, traveling toward a patch of pink smoke, a strip of swamp. It feels important to say: a collage can sound better than it looks.

My father's uncle Jimmy was gay, and a photographer. I am attempting a séance of sorts, a queer, cross-dimensional, interfamilial conversation, when in my gray notebook I write a description of his photographs, followed by a colon:

Shirtless boyfriend:

Elephant:

Women in road in Korea:

I speak to two little girls on the property where I'm staying. They are cousins. One of them has her gaze down when she talks about her grandfather dying. Tomorrow will be her sister's second birthday. They are eager to chat. When I first saw them, they were in the middle of deep play. Shouting to each other about an emergency medical situation, unless there was a real medical emergency that for some reason I couldn't see. They had built imaginary scaffolds of a different reality, so when I got to the car, I moved through two worlds at once. I mean—at least.

K and I were together for a few years. We thought we might always be. We lived in Brooklyn for a while. It wasn't exactly a breakup. She drove me to Tucson, and we camped through Utah's red deserts. Stayed at the Grand Canyon during fire season. We were the first car in line during an evacuation. The next time I went to Homer, we were both dating other people.

A White lady at a restaurant is telling a story about the time she "lobbed her Chinese food in the trash." She is saying *fucking* a lot. And *mister*. She rolls her wrists. Her companion has ordered scallops. I order a Gorgonzola salad; Tom Petty is playing. I was so scared she had a gross story about why she lobbed her food into the trash that I held my ears closed for a time. An East Asian man with a veteran's baseball cap is eating cheesy toast and meatballs on a wooden board, watching a small screen with children's laughter coming out of it.

The guy at the window says, "He's a friend of Gregor's." The guy with the veteran's hat decides on a to-go box, "Let's not waste it." Who are we here? If a tsunami alarm went off, we'd need to look more directly at each other. The people at the bar walked by earlier with a dog wearing a "bear safety patrol" vest on. I was struck by how happy the dog seemed.

The man working in the store across the way seems incredibly bored. I get it. He keeps looking at the window as though something FANTASTIC is about to happen. "Like fried green tomatoes," the people next to me keep saying.

I just ate the most magical fish—sable with miso sake marinade, jasmine rice, sweet soy, beech king oyster mushrooms, caviar, some kind of berries. The people at the bar

are talking with the waitress about their kids on Facebook. "He started out reading the names of the forty-nine kids." They are gushing with pride, but also they are talking about gun violence.

Four people just walked by. We were on the plane from Chicago to Anchorage together. They have left their babies somewhere.

The White guy behind me keeps muttering about White people and lactose-free milk. I can't hear exactly what he's saying, but I keep imagining turning to them, becoming friends. Now, he's marveling at the tongue feel of chili oil. "This is great, but you've got to warn people because it's hot as fuck."

There are Russian Orthodox families living in Homer, women with hair covered, hot-pink dresses, buying organic coconut water at the Safeway. One father keeps smiling at me. I wonder if the women in line in front of me watch reality TV or listen to Kanye. Meghan Markle is on the cover of *OK* magazine looking pissed, and a headline swears she was banished from the castle, or Buckingham Castle. Palace. I watched a video this morning of people arguing about the royal wedding—"I love gospel music, but this is Britain," a woman in blue was saying before she was interrupted by the light-skinned Black guy, who wanted her to stop being racist.

I see a man loading water into his car with a gun strapped to his pants. My first summer here, we got water for cooking and washing at that same spigot. We filled giant red containers and lugged them up a hill.

A moose grazes raspberries outside of the tiny house. I watch for some time, charmed. Through the window in the door I sing to her: "It's Hard to Say I'm Sorry" by Chicago.

Shit, I say to myself as the moose walks over to my rental car.

On the episode of *This American Life* I listened to driving in, Jelani Cobb talks to a scholar from Ferguson who doesn't believe activists are being murdered by White supremacists or the police, just that they are forced to remain in a world where people are murdered frequently. His point is that this, in and of itself, is not *not* a race-related conspiracy.

Is it just me, or have White men just screamed themselves awake into a murder mystery of their own making? I keep wondering whether or not a man I know has stolen a painting and planted it in our basement.

The last time I saw K and her current girlfriend, we heard a strange sound. At first it sounded like a father cooing to his child, but there was an odd energy in the child's response. The child was not a child, she was a woman, and she began to scream for help. His voice was eerily calm as he trailed behind her while she pounded on passing car windows. K and her girlfriend began to follow them, called 911 for help. I was a coward in the doorway. The man's brother pulled up in a pickup truck. Gunshots rang out. The pickup truck's reverse lights went on. We thought for the rest of the night that the woman was dead.

In the dark kitchen, we lit the incense cone from a German Santa ornament because we could not figure out how else to barter with the unknown. Smoke curled out of his pipe as we moved through phases of rapture: first terror, then concern, and eventually, unthinkably, perhaps because we had stumbled into a feeling of family with one another, a rash of unbridled glee.

A collage I've made to signal to myself what I want this book to be has a rock like a meteorite, suspended over the curve of a pink jellyfish. It's a color study. On the left, an ancient sea creature's skeletal hand reaches out at the same angle that two shadows fall across the pink beach to the right.

I cross the street toward a bagel place, order the hot lox on a salt bagel with a maple cortado. I'll try capers! It's a new day! The barista has the quality of Idgie from *Fried Green Tomatoes*. What is in the water in this coastal L-word town?

I see a purple-shirted familiar face. A friend of my ex. "Do you remember me?" I ask. He is trying hard to place me. "The other colored girl!" he says, so absent of malice, so waywardly grasping at the memory that gave him permission to shout the word *colored* in a public establishment this loudly, that I do everything I can to contain my reaction. I smile patiently as he searches for the punch line, but it's a beach ball, it's elsewhere. I know my ex wouldn't have said *colored,* though he tries to trace it to her, so I wait as he course-corrects. "No, no no no no no no no no." We are swerving somewhere: "The other *mixed* girl!" he shouts. It's too late for anybody to feel relieved. I feel like I've witnessed someone falling out of a boat. He is flapping. He sits. He can't tell if he is supposed to flirt his way out of this or what, so I back away. Everyone behind the counter is watching. I keep it chipper. I say, "GOOD-BYE!" I give him a task to complete as I walk back to my table.

The reality is that I'm just someone's ex's ex who keeps wandering along the side of the road.

A bald eagle is circling, and I'm carrying half a lox sandwich in my hand. I get ready to pitch it if need be, in case the eagle needs to be thrown off track. I press my thumb into the orange meat. I am annoyed with the music that plays in my headphones; this app is reading me wrong. Iron & Wine is WAY TOO WHITE for right now. I switch to Darondo, who keeps asking if he treated me right, but I'm too scattered to feel soothed by his defensive crooning. Overcast days here make me feel aimless. My bra straps have leaked onto my shoulders on account of my slouching.

I saw a Black man at the gas station yesterday. One walking near the hospital. And one in a green vest getting into his car at the beach.

We are at about bald eagle to seagull proportion to the Whites here.

In my lofted bed in the tiny house, I wake up and read an article about abortion by Jia Tolentino. I recognize the name of the pro-life movie she describes from the Homer marquee.

A flock of gorgeous animals curves over the bay, tilts toward me, white winged, and floats onto the grass in the property descending toward the road. The birds look ready to take off again. Unsure of what to call them, I gape. Here they go, a bit to the right. One is flapping.

My coffee cup looks like the scene of a car accident for some reason. Are they cranes?

Last night my father looked up the demographics of Homer; "You may be the second African American person there." I did not tell him I had been quietly calculating the possibility of my own murder, imagining parts of me ripped, sliced. I never felt this way any of the other times I lived here.

One of my goals for this trip is to figure out why Jean Toomer marked each section of his 1923 book *Cane* with an incomplete circle.

One Christmas, I sat in my aunt and uncle's house holding my grandmother's hand while on a giant TV screen people slaughtered each other on a submarine.

A cousin of mine does not like the fact my father married a White woman. She warns her son not to bring a White girl home. Once, I looked at her from across the room and realized she was radiant with disgust. Because of this, I know my Whiteness can be read as an iceberg, a warning.

In the kitchen at Christmas, I got to chatting with my cousin's son about college. He quoted his favorite line in *Cane:* "Rhobert wears a house." I was ecstatic. It was as if we had found a private code. In our shared world, one person could look across the room and find "a dead thing in the shadow which is his dream." He had a crush on a Japanese girl in his class, and I began to ache for what this might set into motion with his mother.

Toomer's fragments, in the context of me and my cousin, read like wild curves. Family lopped off, wayward tendrils reaching back toward itself.

Circles start and stop inside the lives of these characters, throwing them places like incomplete stage directions. A

character "circled the fringe of the glowing," or "turned, and staggered toward the crest of the hill."

In one story, a woman says, "All right, girls. Alaska."

Three days after Christmas this year, I overhear an aunt saying to an uncle that she is glad she's going to die before whatever happens next. He agrees, and I say, jokingly, "We can hear you." But they don't look up. What they've seen of the future in the past prevents them from registering my voice.

On the cover of Jeri Ferris's book *Arctic Explorer: The Story of Matthew Henson,* Henson looks like the lion from *The Wiz.* A fur hood cloaks his upward-gazing face. He has a mustache, and a wrinkle slicing into his forehead. He became close with the Inuit living in the arctic climate and learned valuable survival skills through intimate relationships with them. He even helped raise a young boy. Once they reached the North Pole, Robert Peary, the White man who was credited for their voyage, only spoke to Henson to give him orders.

One of Claire Denis's films has a scene with a knife like nothing I've ever seen. In *Cane,* men carry curved blades. A rat bleeds out in a field. At a picnic, my sister-in-law tells a group of us the story of the *Amistad* mutiny. She gestures like she's breaking a lock, imitating the moment when Cinqué realizes there are hundreds of machetes on a cargo boat moving along the edge of Cuba.

At a natural history museum exhibit on the Underground Railroad, I searched for objects shaped like Toomer's fragmented circles. I found a blunt, curved, metal instrument with the handle of a hammer. And shackles.

In the next room, in a diorama of a Native village in the Arctic, I found the shape of a crescent in the fake blue sky.

The second summer I spent in Alaska, I was returning the dog named after a bird. He lived with me while K went to boat school. He whined from the belly of the plane for the whole ride from Anchorage to Homer. I watched her fall in love, in slow motion, and had started dating someone new myself a few weeks before. I spent the week in a small cabin, smoking weed out of a raw potato, listening to Regina Spektor sing "Samson" and "On the Radio." I cried like cracked Tupperware, for hours, on the floor. Then I got on my bike and went to the writers' conference at the end of the spit, where Maxine Hong Kingston told the story of her book being destroyed by a fire.

Clouds evaporate off of that mountain. The sun seems caught between peaks, and also isn't really in the sky. The rain is slight, but the clouds are darker. If a student wrote that description, I'd circle it and draw a question mark next to it.

A woman walks, kind of delighted by the ground, but maybe she is performing something for her grandson, competing with her husband for "best adult," "adult most fascinated by the planet." She reminds me of Joan Didion, but meatier.

It looks like a kayak has overturned in the bay. A blue Wint-O-Green-colored curve of plastic in the water. I see four

kayakers now. Will they come back to shore? There was an intense radio commercial for life jackets yesterday.

Homer is full of ghosts. I remember K's best friend's big-gummed, blue-eyed smack of boy beauty. Husky-voiced. Her dog was not named Nine, but memory is what it is. She seemed always entangled in bad love. What is a nostalgia project? It's been hours since I woke up and it's still not lunchtime. I'm amazed at how many hours there are in a day when the sun spends only a few hours below the horizon line.

In Tucson recently, a friend found out her father died in front of the house where I was hanging laundry. The entryway where she screamed opened something up. Our dogs, normally peaceful toward each other, had a fight. A javelina charged the front door. A friend gave us some salt mixed with the remains of a roadrunner to sprinkle on the thresholds. "You have to tell the spirit of her father that she will be O.K. Bring him flowers." I called my own father and listened to him talk about his best friend, who'd recently lost his wife. Some other guy his best friend had recently reconnected with from childhood would sit with him in the car, and they would smoke cigarettes for hours. My dad sounded left out: "I can't be around all that smoke," he said. This is how I'm accustomed to talking about ghosts in the desert.

The next collage: Jellyfish anatomy, like the X-ray of a flower, reaches across lines and color. Some text, a rug.

Something is swimming. I almost wrote, "I am the most interesting thing on this beach." This is not how I talk, but when there is no Black figure, what am I supposed to like looking at? I think it's a sea lion.

I'm waiting for a head to emerge, moving my eyes along the water. I think it's an otter because, no, yes, because it's a triangle of dots. And then it flips into the water and disappears. Is nature writing just biding time until you're hungry enough to eat?

One summer, we went kayaking across the bay. We went to an island where Jeffrey Eugenides stayed. A remote retreat, a stranding. The island was magical. We saw caves? It felt especially purple in places? I'm thinking of the band the Lovers. Waterfalls, fear of bears, crossing over. I can't bring it onto the page. Whole beaches, I can see it, but words push it away. We ate lunch.

I don't know how to be me and write about nature, or what I'm seeing. I don't know the names of anything. I wanted to call seagulls *kayaks* a minute ago. The starfish scare me—

are they dying? Always underfoot! Reddish, a good bit of yellowy puss at the center, but leaning toward purple.

Things I want: to see a whale, to not talk to anyone or be killed, french fries, friendliness.

The phrase I wrote as a possible topic for this portion of the manuscript is "sperm donor."

What I'll say instead is this: *Harold and Maude.* A friend and I watched it next to a boy with bewildered eyes. We welcomed the world like dervishes. She's the one who prompted me to pick up and move to Boston. She and I don't talk anymore. I can't remember what I did to break it. The feeling of looking at the sky after Bud Cort fakes driving off a cliff lasted us for almost twenty years of friendship.

Today I call the glacier hike water taxi to confirm it is too late to go out for the day. I'm not really planning to go, I just want to make sure I can't. "We aren't able to take you today." I am delighted. I throw the phone down and shout inside the empty tiny house, "I tried!"

Hot pink is super in today on the beach. I'm straddling a log, looking around, waiting for nothing to happen.

I'm looking at a bald eagle that is standing on the ground, maybe the length of a grocery aisle away from me. Listening to Chance the Rapper. The eagle flies off just as I get to the point of drawing it.

My queer haircut side shave is growing out. I'm shabby. My hair is not the same as it was when I was here before. That was: mane.

The tide is low. I pass patterns of human and dog prints, move toward a creek that is just deep enough to require a leap. I look at all the rock options for crossing. Someone to the left approaches. A woman in hot-pink clamdigger pants is looking down.

I try to decide whether or not to jump across the thick rivulet of water, and begin to imbue the gesture with too much meaning. I decided to go to Homer for the first time while standing on a forked path. When I don't leap, I wonder what I'm missing, as if worlds only open in the direction of the unknown.

Another ex-girlfriend I went to Alaska with seduced me by embodying the personality of the desert. She rode by me on her bike then swerved. Just like Jolie Holland had been telling me on repeat in a song where she sang the word *bike* like it was a cracked bowl. One night, we sat looking at an 8½" x 11" sheet of computer paper while she drew her dream, an underwater, celestial map. We biked around Tucson like swooping crows. Passed a security guard playing saxophone at the entrance to a garage. One night, she crashed her bike and dove face-first into an island of cacti. She drew a whale long after we broke up, and I made it my third tattoo.

When we flew to Alaska, we checked into the motel in Anchorage after midnight. The desk clerk told us our dog, named after an author, another black mutt with regal ears and a diamond on her chest, looked like a Chupacabra, and looked Chupacabra up on the internet. We waited for the screen to load so he could show us documentation of a mythical creature, charmed.

We camped on a friend's property. K was there with her girlfriend, and the girlfriend had very specific rules about where exes were allowed to be in relation to one another. She conducted a campaign of sorts, taco Tuesday notwithstanding, that made us feel less like we were camping and more like we were homeless. When it rained, we spent the day at the public library, looking through DVDs. I was writing my master's thesis on a heavy laptop. Tried to lay the printed pages on a floor when I could find a dry one. We found a man who lived in a cabin shaped like an egg in the midst of all that purple fireweed. Biked long miles, drank coffee, drank whiskey with a woman with a *Jo* attached to her name. People took pity and began to give us house-sitting gigs. We showered across the parking lot from a bar. Our dog's ears went straight up in the middle of the night in the tent while she growled at a register below earthquake, and we'd squirm, anticipating a bear. We didn't mind the rain so much when we could get french fries or breakfast sausage. I always intended to give the host of our campground a red vase as a thank-you, but we never sent it, the entire summer a botched rendition of the original.

Of her *Public Sex* series, Lorna Simpson tells Anna Novakov: "You are in a national park. You are with one person but are remembering when you were there with someone else. There

is a layering that you don't want to reveal. You have nostalgia connected to someone else. Private memories emerge while you are trying to pretend that it is something new."

The photographs that comprised the *Public Sex* series were printed on felt, arranged in a grid. No figures were present. My favorite one is of a fire escape. There is also a rock. Recently, while looking at it, I realized that, indeed, I had a rock like this with K.

In Iceland there is a library of water, created by Roni Horn. I wanted to go, but one of my travel companions created an itinerary for us along the Golden Circle, so I quietly pouted as I drove farther and farther away from the library, the only one of us who could drive stick shift.

Anne Carson stayed at the Library of Water. In her annotation of *Wonderwater*, a pale-blue book published as a collaboration with Roni Horn, Carson writes, "Can we draw a line? Where? Is there a map? Is it less lonely? Or at least less primitive? Or the way Artaud undresses it—'my soul (today I have no soul and I've never believed in its existence) is always tending to go black'— can anyone say this? Can anyone know what it is?"

"Mic drop?" I asked a student the other day, after she had spent the last five minutes dancing for us in the middle of the room.

Lorna Simpson, *Ice 6*, 2018. Metallic rock faces. Like a poorly developed photograph, brown sheen. What is it about the intractability of the past? Why does the mere fact of having been younger once feel so excruciating? I can't get back inside it. The rock face looks slick, like you'd slip, like it's a screen. Like buildings. A city of glaciers. Is that like the future? Would it be like a city at all? The feeling of falling is a thing I keep refusing as I look. There is a way that time and emergency take on a similar texture. The front end of emotion, before you know what it's for. Grieving for something ineffable. Just before or behind you.

At the Old Inlet bookstore, I walk in on two men talking about nuclear war. I wonder if they were inspired by the Russian war planes that flew into U.S. airspace above Alaska last night. They talk about how close we are to it, as close as the Cold War. One of them read a book about a man who was trying to get to his family after nuclear fallout, but the cloud was coming. The darkness was spreading. The whole earth would end no matter where the warheads fell. One of them talks about a podcast. He says a woman had gotten about seventy sources to admit Area 51 was Stalin's doing. He killed four of "his own" and did plastic surgery to change their appearances, then had them crash a plane over Area 51. As soon as they dissected the "aliens" it was all human being—appendix, etc. But they were so embarrassed that Stalin had gotten into American airspace that they couldn't admit to it.

Then they talk about Nosferatu.

There is an excellent collection of books here. It's not organized for shit, but I buy a first edition of Borges's poems as a gift for my wife.

Later, I ask one of the men if they were talking about the Russian warheads. "Oh no. They do that all the time. And

let me tell you—so do we." He has blue boxes in his eyes, somehow. We discuss Trump in the kind of way that makes me sure he hates him, but we still end up in the middle of a tonal tête-à-tête because of what listening means. The rest of the town is pretty red, he tells me, relocating us onto the same side of things. By red he means a thing called "Green Republicans."

I am crying on the spit. I stand still, looking at the view, and I think, *My ex-girlfriends are the glacier.*

I am imagining Lorna Simpson wandering around Homer. Or on a small plane, off to watch bears. She has a deeply sophisticated vibe. What would that look like in a windbreaker?

Today has lasted awhile. A group of people are furiously sawing at what I desperately hope is just driftwood. At the store, I get kombucha and broccoli and vodka sauce to make later.

I look up prices for bear tours. Just the idea gives me a jolt of adventure. Then I shower, wondering if it's O.K. if the shower is my adventure. I make myself dinner on my small electric stove and sit outside with my new watercolor pen brush. There is more pink and green in my painting than I expected.

In each of Simpson's *Ice* paintings, the sky is above and below. *Blue Earth/Sky* has an undoneness—not clouds but paintlessness in the blue. A careful eruption of clouds underneath. Panels of text descend vertically. Mountain like a woman reclining. Head unseen. Shoulder a sharp peak. Long neck. She seems to be peeking underneath the horizon.

The articles I've printed about Lorna Simpson are like the text that slivers through her paintings, missing chunks. *Wallpaper* magazine: "One night recently, Zora, her 18-year-old daughter with fellow artist James Casebere and something of a social media it-girl, read her a passage from *The Secret History* by Donna Tartt and the word 'unanswerable' jumped out. 'I feel it doesn't get used very often.' It connotes, she says, 'silence, and the posing of a question that, in its context or premise, makes no sense. There's no answer, not because it's "unanswerable," but the nature of the question makes it unable to be answered.'"

Renee Gladman writes, "I wanted a threshold to open that also would be like a question, something that asked me about my living in such a way that I could finally understand it."

I recently realized that Lorna Simpson's daughter is a model for a jewelry company created by someone I went to high

school with. I've asked my wife if I'm allowed to mention this here, and she isn't sure. Just the equation—my first-ever obsession with coolness + the daughter of an artist who taught me how to hold my Blackness [× being biracial to the power of ten]—is what I imagine cognitive behavioral therapy might feel like. Which is to say, race was in there, somewhere [high school] and, suddenly, she's been taken out. Nay—bejeweled.

I have at various points in my life remembered and forgotten how to walk through the world with my glacier helmet on. "Like an African," my father might say, because of this thing that happened to him once.

Listening to Grace Jones sing "Nightclubbing," I say *fuck it,* turn into the parking lot of the maritime center. I'm bored stiff. A woman with a leaf blower and a nose ring smiles. Revs the engine of the leaf blower. How are there so many lesbians here?

When I enter, a woman looks up. "It's free," she says as I pause with my mouth open. She sends me to watch a film, as if she can read my listlessness.

The film shows the Aleutian chain. The study of, by boat, marine mammals and seabirds. "They look like beehives," someone says of an island of seabirds. "More seabirds in the refuge than in all of North America. Twenty or more species." The scientists see "cliff faces, burrows, grassy volcanic hills." Fork-tailed storm petrels. Red-legged kittiwakes. "One egg per season." They speak of birds with a "tangerine odor." Someone says, "All of a sudden, all these birds appear." Someone says, "Sheer waters."

Russians and Americans hunted the sea lions and seals nearly to extinction. Otters are beginning to disappear.

"Wasn't a day when we didn't see something that made our mouth fall open."

What if I left a note in here that I forgot to edit out that said something like: "Being referred to as 'strange' by my sister at Christmas and feeling weirdly complimented."

My favorite thing about the documentary about Grace Jones, *Bloodlight and Bami,* is the part where we go to Jamaica with her and watch her for long spells walking outside or talking to her family over dinner. Her personality engulfs a music hall, then bam—cut to her brother telling a story of their childhood on a bus as they drive to church. How did she happen? I show the church scene to a class I'm teaching, but something clearly doesn't translate, or something of the scene, decontextualized, hasn't translated to me.

A collage: Fire-inflected circle, horizon line on the vertical. A woman with pink hair bending over. Our strangeness an attempt to smash back into the natural world.

Everyone I know in Tucson has conversations with insects and animals. We text each other photographs of coyote, javelina, and hawk.

John Keene: "What I learned from you: how to glide out of fate's schedule. Un-time oneself."

A woman on the beach sand is painting a small canvas on an easel. On the restaurant patio, a young man tells a story of a journey, and two listeners keep interrupting with questions or similar stories. I keep falling asleep. Now the other guy is telling the story. The lady asks for details, coaching them to tell a better version. Two guys keep saying, "What the hell, man?" She and another guy keep asking, "So what did you do?" He tries to explain: "The guy was just an asshole. He was all up in my face screaming."

A boat is surrounded by a cloud of gulls. "We were just so dumbfounded as to who this guy was or who he thought he was." Younger guy tries to take back the reins—he focuses on scenery. "I go around the trees." He is on a roll now: "WHITEOUT conditions."

Donna is the waitress. She explains: "Weather comes from Japan."

I am beelining toward what looks like a seal's face. I think a lot here about whether animals can sense me from the corners of their eyes. Sun's rays blah blah, gray. I can't find the seal. Writing in nature is becoming a form of self-entertainment, warding off boredom. I am keeping myself company. The color of the water is mute gray blue.

The island across the bay brings to mind *Island of the Blue Dolphins.* Because it is an island.

My hand is wet and ashy. So far I've seen two Black people today. One teaches a small White child how to fish while seagulls scream underneath the pier behind them. One sat outside a sushi restaurant, smoking.

"I don't know that it's possible to be clear when it comes to these kinds of things," Fred Moten explains.

There has been a truck with a Confederate flag at a beach where I used to take the dog named for a tropical bird to swim. Once, I had a whole conversation where I kept saying the dog's name, and a friend who thought I thought there were tropical birds in Alaska would correct me with the bird she thought I meant: "Puffin."

I walk diagonally away from the Confederate truck toward the ocean. I look back at the beach, stripped driftwood gleaming in a kind of silver pile of horizontal textures: sand, rock, clouds, white glow of backlit clouds. There are ridges in the sand, tough enough to resist my footprint. The first summer I stayed here, I took pictures of driftwood, glued them onto cards, and sold them at the farmer's market.

Every dog looks like a wolf to me these days. Even border collies. "He's a puppy," one man says as his labradoodle bounds toward me.

At the beach, I write, for some reason, "I am scared of pickles and dogs." I walk, low tide, to the edge of the water, sensing, despite the increasing iridescence of what I see, that I'm approaching something dangerous. I get to the rocks and turn to see a bald eagle. I raise the phone camera to film it and decide it's coasting right to me. Video footage shows

I grasped at the phone, raised it to the eagle, then tripped into a run.

Two eagles are near the top of some trees, and they make that beeping sound. Aliens.

At a café, a woman tells the story of, like, forty eagles. Some kid caused a disruption, and the eagles flew off. I cannot fathom it.

At lunch, my waitress compliments my dreads and asks if I like reggae. She doesn't like it much, she says, but she listens to it. I feel like we are playing house; the conversation feels like it has its own rules. She is from Jamaica, has come to Homer three summers in a row for a cultural exchange. I order a burger with fries that taste of coconut oil.

As I eat, I laugh at a line from *Voyage of the Sable Venus*: "If I were a name, / it would be *Wall / paper*." In the mirror of the Land's End bathroom, I am delighted by my own reflection. I have to be my own friend here.

Robin Coste Lewis gets my mood: "For five thousand years, / I have listened to you / think aloud about a world / that does not exist."

White streaks across the bay are the wake of a boat. I am not awake. There is something romantic about these waitresses. We eye each other, similar, endangered. A family of White Christians just walked into the room. The boy is black blazered, cross wearing. His voice like a strangled wisp. I am furious about abortion today and keep thinking about the miscarriage I had earlier this year. It was the size and shape

of a piece of fruit that had been forgotten and smashed in a Ziploc bag. They almost had to do an extraction when it didn't come out on its own. How many things have we done that could land us in jail as these laws float into fascism?

Robin Coste Lewis collages the titles of paintings into this list of Black figures in art:

"black / laborers on the quays / of Venice. Black African figure / at the edge of the canal, miracle / at the Bridge of San Lorenzo."

"Negro Woman Seated / at a table, facing / left, writing / with a quill."

In the mystery novel I'm reading, an African man dies in Venice. The first hundred pages of the mystery are made up of the detective noticing that he knows next to nothing about Africa. Finally, he talks to someone. Finds a salt box full of diamonds. Normally I like this detective, but he keeps smiling churlishly, unwilling to say whether or not he means it when he makes a promise to an African.

Lorna Simpson has an entire series called *Riunite & Ice*. A woman wearing what looks to be a diamond necklace is placed below a series of hairstyles. These hairdos are composed of:

1. Painted cloud, ripped-up mountain, close-up of a stone

2. Brain map, another woman

3. Blue watercolor, assorted diamonds

4. Black watercolor, red siren

5. Traffic through a window? Landscape from above?

6. Blue cloud night sky, full moon

7. Glacier

8. Man made out of a glacier

9. Upside-down building, under construction,
 above a White lady, sensual

10. Clouds, aerial view of construction, a ladder

11. Gray paint, stubby abstract tree figure

12. Gray paint, checked pattern

13. Forest + ocean-colored swirl

14. Variation on #13

I write a list of Black figures in Alaska:

Black girl walks down a road, near gas station, talking animatedly on her cell phone. She is short. Her hair puffs out, curves. She wears a black windbreaker with hood.

Blackish man spotted on Pioneer Avenue. Beige hoodie.

Library—Tessa Thompson–style girl holds the door for me before turning to go back inside.

Negro Woman Seated / at a table, facing / left, writing / with a pink pen.

The collage I've made to make space for something at this point in the manuscript is a mess of torn blue sky. Black lizard-looking rock on top of black infinity. "Because you're not excavating; this isn't an archeological dig or an archive," my editor says. Normally when I write, I place myself next to something "real"; I use the anatomy of that something "real" to guide me as I go, so nobody can blame me for mishandling the body of the book the way I turn bodies into blobs when I'm drawing.

I complain to my therapist about giving myself away. "But is it you?" It always surprises me when she says something so clarifying given that I'm sitting in front of her, pulling a series of soggy cotton balls out of my mouth and looking at her with increasing alarm. It is around this point in our session when I see what talk therapy "is," as we've ended up here laterally and backward, like a book with no "real."

The collages are, like the gray notebooks, a system outside of myself to keep me contained. Otherwise there would be nothing but freefall. Black lizard-looking rock on top of black infinity.

Saidiya Hartman speaks of slaves who escaped into the insides of trees, who left no trace of themselves.

At the museum exhibit about the Underground Railroad that I wandered into the day after visiting my nephew in prison, a small space was meant to replicate the attic where Harriet Jacobs stayed for seven years, hiding.

Two little White girls arrived and stood outside the crawl space, clearly wanting to enter the attic replica, even though I was sitting there, doing as the placard instructed: listening for the sound of my own heartbeat.

I climbed out, an annoyed adult, sulking to be prematurely extracted from a simulation of slavery made for children. Ilana Glazer, whom I still can't help but read as Black, has this joke about how she was terrorized by Holocaust simulations in Hebrew school. It is and is not a joke.

Two women come for clams because it's the mom's birthday. Clams are off the menu. Maybe they'll leave. "What is she eating?" The daughter points to me. Fish tacos. Will they make them without batter? The waitress checks, comes back: "He'll grill it." I am filled with anxiety that they are not going to order these specially made fish tacos the chef has O.K.'d.

They talk about waitressing with the waitress. The daughter wants a job. All of them have done it. The waitress is a certified social worker who retired. She was watching families go through hell. Now she gets to see people, interact, and enjoy herself. Otherwise she'd "drink herself into a stupor."

Daughter and mom are a bit uncomfortable with each other. Skittish or annoyed. Mom knows the daughter doesn't like her boyfriend. "He's Christian, whatever." Daughter to mom: "You're comfortable in the wilderness. You'd know how to survive." The daughter, husky-voiced, talks in an Australian and then British accent. Now French. She tells a story about surfing with her aunt and tricking French people into thinking they were French. It's like she's performing for her mom—shifting into a self who knows how to enjoy their time together.

They're going to leave without the grilled fish tacos. Some-one's phone, the daughter's, sounds like a movie from the nineties. If I had to guess, she's embarrassed about her mother's class presentation.

Mom tells a story of being across the bay and a woman not being able to pee. Shouts the word *penis*. The daughter morphs again into a different self, seems almost to coach her mom to follow her there. It's like she's dissociating. The mother turns to me and smiles.

Beaches tend to mean your ear hurts a little; the wind is loud. Who burned this beach wood? My shoes are wet. Supermarket Ginsburg. Who killed the peaches? What price tomatoes? Are you my angel? I think my kind of pastoral must include gossip. An overlay of dotted lines: suspicion, intent.

The fog has lowered itself like haunches over a toilet across the tops of the mountains. I turn and a crow is headed at me.

My fear of birds and assorted creatures here is not entirely unfounded. One year, walking with the second ex-girlfriend and our dog, named for an author, I turned to see an owl swooping toward us. I screamed "NO!" and it changed course, angling upward. Another time, a moose followed my dog and me as we walked, and it continued to walk parallel to us even after we crossed a busy road. I think the moose thought my dog the author, a puppy, was a moose calf.

On the beach, I am a clenched city dweller in all black, waving away the wildlife. I worry this beagle will run up on the eagle that's sitting on a rock. What is this brown lump on the log? Everything makes me feel suspicious.

Some bird keeps saying "turtle" behind me. I only trust the cranes. I see German flag colors a lot here. My nose is running. My eye has been twitching. The rocks look like whales in the bay. This dog just faced off with me, leashed. I probably stink of fear and diarrhea. I think the water is making me sick. Another eagle has landed. I'm out.

According to the moderator of Fred Moten's conversation with Saidiya Hartman on the Black outdoors, "It was Jean Toomer who tuned that 'there is no end to out.'"

This is weird, though. The eagle is flanked by two other birds—crows? Falcons? Eagle babies? A child shrieks in the distance while these large birds converse in a trio, just *standing on the ground*. Are they talking about fish? The planet?

I am staring at the birds. I sit in a scattering of driftwood. Paul Simon once sang of "scatterlings." You may remember that he spoke of "spinning," too, and "infinity." It has been suggested that I paraphrase, because of the law. Paul Simon must be one of my biggest literary influences. I've been sad ever since I saw him standing in court with Edie Brickell over a noise dispute.

The log I'm on is spongy. That's, uh, white moss. Is that a thing? There are dandelions. I don't mean to be an ass, but I feel again like I'm the most interesting thing on the beach. I mean: a lone Black woman walks out during low tide, begins to film a bald eagle, then runs away screaming.

My father's uncle Jimmy took a photograph of a helicopter while he was deployed in Korea. It took me ages to figure out what the helicopter was. The print is blurry, black and white, but somehow bluing into an aquatic animal, a giant squid whose affiliations seem impossible to ascertain.

As I type this, it occurs to me that this could be a very loose way of describing the plot of the film *The Host*. My gay great-uncle, a documentarian of Black and White servicemen and the everyday in Korea during the war, *should* be in conversation with the filmography of Bong Joon-Ho. Think about it: Black [gay] soldier occupying foreign territory, photographing White men who won't live next to him at home. *Parasite. Host.*

I guess I was trying to fictionalize his experience when I wrote, "He tried to catch it as it occurred to him—the feeling of invasion they all felt."

The opening strains of Björk's "Bachelorette" play as a bald eagle opens its wings above a lamppost on the spit. Another eagle, seated there, is being ousted. Accepts the rejection. Lifts, hovers in the air. Descends. Tipping. Coasts to the roof of a fish-and-chips place, where a crowd of people watch it do its baggy-pants landing. White blond lady, White kid, and Black man all come out to watch it from the dock, then reenter the restaurant. I need to pass under the other eagle, knowing it's there now. Björk sings of a killer whale as I approach. The music is symphonic, gusting.

I had been looking for the ferry terminal, just in case I might go to the glacier, but now I'm peering at an eagle's chin. Björk sings of neon. Because of where it's sitting, nine lights could blast on beneath the eagle. "Were you the one from Bishop's Beach the other day?" I ask it. The music is like an eagle bleep. Bleat.

Being alone is a whole thing. Tell me, do eagles get bored? Björk says that I should not get angry with myself. She will heal me. But she'll be using razor blades.

I thought I was leaving tomorrow. But I don't leave until Saturday. A Black guy gets out of a truck with a White lady in an explosively colorful sweater, and I look at them with

the longing of a child. I don't know how to make friends with strangers and am drowning in loneliness.

Two seals are lounging at the pier, in the water, rolling along, drifting by the boat slips. A dock cop patrols. A boat exits.

Two lesbians pass with a puppy. I recognize in them the progression of shifting moods—apprehension, resignation, apathy, curious eyes, relieved smiles. It breaks me a little that they don't see me as someone with whom to discuss Jenny from *The L Word*, but I know I've had some version of resting bitch face since well before the 2016 presidential election.

The nineties were full of quasi-lesbians played by actresses with three names. An elementary school portrait of K reminds me of little Idgie, screaming after her brother in the train scene in *Fried Green Tomatoes*. My other ex was, even in the present, a kind memory, of a tree, of Pippi Longstocking, ramshackle girlhood, scrappy, exhausted play.

Lorna Simpson, *Ice 8*. The top of the glacial form is evaporating up, streaking into clouds. A corner in the sky is carved like a Rothko. Skinny bracelets of blue paint drip down into the gray weather of the glacier's . . . vicinity. Like white gold or blood on a White lady's wrist. I like the feeling to the left: blue brushstrokes trace the line of the mountains, an imprecise carve-around, like a coloring book. There's a psychedelic quality to the puddles gathering around the ice. She almost did this one as a triptych: three different moods. The center mood feels like a divorce. She's the one who said that's what was going on for her when she made this series. Also, I've been listening to all this Paul Simon. I don't know that I've listened to *Graceland* since Carrie Fisher died. This is the first time I hear it and think, *This song is about Carrie Fisher, and now she's dead.* It's as though she has come back just to tell me that she is already gone. The center panel *is* like a window in the heart. What feels like a visual trace from this painting plays out in my mind's eye as I gaze at a tree outside the window.

This morning the woman next door is taking pictures of a flock of cranes on the grass outside near our cars. "We used to get a hundred at a time," she tells me after I venture out, barefoot, with my phone camera. She tells me that before migrating, the cranes train their young by circling the bay, then one day, a thick black line of them bands across the sky as they leave for winter. As we watch, they keep opening their wings, hopping into a false flight, moving over a few feet, psyching me out.

The second season of a TV show I'm watching is about time. Those movie-wall puddles of past or future. Places you can't reenter. What I feel today: disbelief in our forward motion. How time gains momentum. I want to watch my past life like a film. I want it so badly I could moan. Cranes let out this hysterical croon.

I broke up with the other ex-girlfriend I spent the summer with in Alaska over the course of days and hours. The duration of our breakup, our dedication to that process, was like an art project; it feels retrospectively heroic. I spilled hot wax on myself by accident, because it was the desert in summer, and began to howl. As angry as she'd been, she cooed over me, helped me wash it off. We sang "Careless Whisper" to each other repeatedly, shrill with laughter and sobbing. It was the story of what I'd done to her.

I have just ordered tempura fish tacos and a Gorgonzola salad at a restaurant on the spit. This whole experience is a far cry from the summer I spent living in a tent. A teenager walks by with a camo backpack and a long green rifle, glinting with gold-colored bullets. I eye it, and he eyes me, and I take stock of my options: Who in this restaurant do I ask if this is normal?

The women next to the window haven't blinked even the slightest. One is telling the other that her friend has died. "I'm so sorry." "That's O.K., he was ninety. I think he was ready to be on the other side." I've seen signs in restaurants that say "No Guns," which means people here carry around a lot of guns. This was true in Arizona too, but I can't fathom such casual weaponry in Tucson as this skinny green rifle.

The waitress is wearing pink. Without meaning to, I test her affect against Sarah Palin's, and she's about an eight. Her friendliness seems laced with something. Fentanyl. Perhaps it's me. I'm in a mood because of the boy with the gun. But he has gone down the dock toward a boat. Presumably he's off to ride a boat and shoot a bear. Or maybe he'll shoot into the water. I don't know what's real in terms of options. There are reservations being taken in the restaurant's doorway. "That's a bummer," Sarah Palin says into the phone. My two

ladies laugh over Vinho Verde. I'm working on this bright pile of a salad, quivering with angel hair–thin beets, and I'm eyeing the dock, unsure if the armed teen is off to shoot fucking wolf pups or what.

In a TV show I'm about to ruin for you, a woman teaches a group of teenagers and one high school teacher how to do a series of movements. They don't know exactly what they're training for until it happens. A boy arrives to the school cafeteria with a rifle, and the dancers rise. What happened next? I fell to my knees and wept.

My boredom creates a kind of blankness.

"Distances go silent," Anne Carson writes of her pilgrimage.

I realize now that Lorna Simpson's *Ebony* collages look like aurora borealis. Black and White women with colorful skies blossoming out of their heads. Watercolor universe. Hair as night sky.

Somebody comes to mind as I look at one. I realize, after staring for a while, that her name appears at the bottom, a small clip of text. My heart constricts because I am sure she does not see an aurora borealis attached to my skull when she looks at me.

Q: What do you call it when you can feel that someone cannot see the aurora borealis attached to your skull?

Samiya Bashir writes,

What is a thing of beauty / if not us?

Repeat:

The last time I saw my nephew, we sat in a large waiting room with sunny, cloudy skies painted on the walls, a backdrop for photographs. The room was huge, like a high school cafeteria, and as I waited for him to come out, "which could take a while," I watched families sit around tables eating vending-machine food. Sandwiches. Clear sodas, for security reasons. I kept trying not to smile too hard at the woman with bright-green hair I came in with, who loaned me a quarter for my locker. I kept my eyes moving away from faces and bodies, seeking inanimate objects to gaze neutrally into, though blurring my vision meant I would accidentally land on a crotch or a neck tattoo, causing me to panic, turn my head suddenly, and blush. Once he did arrive, a tall, strong man smiling beautifully from across the room, there were no open tables, so we found a place to sit in what looked like the waiting area of a train station. I practiced not flinching at every loud noise, looking to his eyes for guidance. Something slammed or somebody screamed, and I held still, waiting for a cue. His eyes remained soft. And the world seemed to soften in response: The scream was a baby. The baby waddled up to us.

At one point, the guard called him over and told him, "They said to stop doing what you're doing." I retraced the last span of time in my mind in search of some sort of language or

maneuver that might have been a problem. He laughed and told the guard he didn't do anything wrong. He sat back down. I kept waiting for the guard to get mad at being told what was what by an inmate, but the guard kept his gaze down, almost obedient. Despite the way our outfits were color coded and who had what weapon, intrinsic power still lives where it lives.

I asked about something I read in the news, about how this place was on lockdown a little while ago. My nephew told me the story of how some guards got sick after touching mail that, the prison claimed, held a paper version of marijuana you can lick to get high. The whole thing was a literal play: guards pretended to faint. It was an elaborate scheme to get sick time. Now you have to send mail to a separate facility for "processing," which just so happens to give business to an entity affiliated with the owner of the prison. It's like prison is a poorly acted play he's had to watch for years and years.

We discussed mass shootings. Astrology. We contemplated our rising signs. He had the physicality of a monk in his burgundy jumpsuit, slow moving, wide smile. He talked about men who've watched television in their cells all day for the last decade. Their memories are shot. He wakes early. Works

out. Reads. I considered the hours of television in my own day and felt a bit dead inside.

After I left, a White woman eating in a booth at the McDonald's glared at me, but something about the visit with my nephew made me walk with the whole of each foot pressing into the ground. The White cashier who rang me up told me story after story about her life with her eyes. She gulped down the possibility told by my outsiderness like someone trapped. I drove in the direction of the Seneca Nation.

This morning, I slid down the stairs from the loft on my butt—at first on purpose, then 'twas not on purpose. This is another in a series of days in which I've had diarrhea. So I slept in. Finished *The Friend*. Read my notes, sang Paul Simon out the kitchen window. My life is more akin to the lyrics than ever. Biographically speaking.

At Bishop's Beach, which has become a ritual for my loosely structured days, it's sunny and windy, so everyone looks a bit mismatched and unbalanced. I'm not sure if we're supposed to talk or what. Beach fashion: seafoam-green corduroy jacket, bright-blue pants. White floral dress, red scarf covering one eye. Hiking boots. This is one person. Because it's sunny but it's windy. We exchange greetings. She is collecting pieces of driftwood. The wind feels like a deep fan, the fan of time, an air conditioner from infinity.

Uncle Jimmy's helicopters, shiny, stacked spheres, remind me of another film, *Another Earth*. The film's premise: What if you lived on two Earths at once?

A dude with a dog encroaches. I leave. It's so unlike me to be this afraid of dogs. My dad calls and asks, "You call?" I did not. He did this in the middle of the night when my grandmother died.

I am on West End Hill at a lookout point marked by a sign with a camera and an arrow. I did not take a ferry to the glacier and hike in. I am stubbornly looking only, the ice floe like a highway. I watched the sun rise the other night, a pink bud above the glacier between 2:00 and 3:00 a.m.

My boredom feels like an aesthetic challenge.

A Black guy in an Apple Maps car with a giant camera drives by. I will be uploaded soon, a gaping face in a silver Nissan, marking this spot on a map of Homer: *The Other Mixed Girl, Bored about a Glacier,* 2019.

In attempting to locate a space for Black people outside of Newtonian physics, Fred Moten says he can't stop thinking of a song by Ray Parker Jr. wherein he speaks of being in two locations simultaneously. On YouTube, Ray Parker Jr. is draped across the album cover in a suit and a purple shirt, in front of a deeper purple background. I blush at the rest of the lyric, which specifies the locations he wants to be inside.

Me, I can't stop thinking about the film *Arrival*.

And I remember now what it is I've been trying to remember about Jean Toomer's circle fragments: they look like the language of the aliens in that film. Amy Adams decodes each smoky ensō left by those floral tentacles on the glass.

The trick of the film is that we think the flashbacks are behind us. The stakes are posed as a mother's riddle: Would you work to save the planet if you knew it (your child) was about to die?

On the way down West Hill, I turn. Immediately I recognize the pale-blue school, the houses, the slope of the road. I recall walking the dog named after a tropical bird past where the pavement ends.

I go to Safeway for a bottle of water. Get a cold brew with honey, seeking caffeine out of boredom. The *National Enquirer* says Aretha Franklin was murdered. I choose the nice checkout lady. Curly Q has been slamming my broccoli around. In the parking lot I look at a Buzzfeed "article" about how the Blue Lagoon in Iceland is actually trashy. I send it to my wife. She often talks about how she has never felt as relaxed as she was in the Blue Lagoon.

I think, *What if this was Iceland. Would I be so bored?* This is as far away from home as Iceland. This is kind of like being in a faraway Ohio.

I watch a Twitter video sent by my wife of a Black boy with broken glasses singing a very sweet rap version of "Fly Me to the Moon." I am, again, interested in my interest, so sudden, so whole, in anything Black.

Sometimes I wonder if Lorna Simpson's paintings are like Jericho Brown's Twitter response to the Mueller investigations. A tautology. Whiteness as Whiteness (colonialism, denial, catastrophe). Ever itself.

The center panel of one painting looks like a video being fast-forwarded or rewound. All of these paintings are shouting but in the colors of grief. We are coughing into the ocean. Breathing in water. Last gasps. A STORM IN THE LUNGS. This is a post-tsunami evacuation route. There are no people in these paintings because, as the bumper sticker says, "Nature bats last."

The music today has been some real elevator jazz.

Lately I've been compulsively painting rooms. When something is due, I drive to the hardware store and hoard paint chips. Because this book is due, I painted a sunset on the stairwell. Yellow fading into pink. There was a Rothko situation as the whole thing evaporated into purple, which my wife requested that we reconsider. So now there are blue mountains that are also like a lake. And these really gay, hot-orange peaks. Gold flashes. Why am I telling you this? It has something to do with time. When I paint the walls, the change in space says something to the idea of an hour. Or, what I wanted to say was that this has never been a book about glaciers so much as it is about landscape, which can be an internal experience Black women who have been called "strange" by their sisters have had collectively, and alone.

In a letter to my nephew, I told him about the time I last saw my grandmother, his great-grandmother. She was going blind, and we opened the blinds. She asked, "What's that light?" The sun hadn't been out in days. "That's the sun," we told her.

I wrote that, come February, Matthew Henson saw the sun again after many months. According to Jeri Ferris, "the crystal clear water in the bay was deep blue, and the air was thick with the sound of wings and songs as thousands of birds swooped and swarmed over the water and up the cliffs."

I was trying to gear up toward a feeling of enlightenment. Of release.

When I found out he was out of solitary confinement, I was teaching in the woods. I shot up from the table and ran outside. I told the first two people I saw, and neither knew what to say, as if they couldn't share my joy until they knew why he was in prison in the first place.

Later, I drove three hours to the airport to pick up Wendy S. Walters, who would be talking to us about loneliness and America. When I told her about the confused White faces,

unable to commit to an expression, she nodded and laughed softly.

In one of his essays, my nephew writes of White people, "Their mouths said hi how are you but their facial expressions spoke louder. Exclamation point, question mark, period, period, comma."

Of his own body he writes, "I felt like a question mark at the beginning of a sentence."

Toward the end of my time in Homer I am moodier; the texture of things feels more numb. But I'm determined to be out all day, without pushing or retreating—toward bear trips or watching TV in the tiny house.

I am on the spit, a beach behind a pizzeria called Finns. Practicing believing that bald eagles aren't hunting me.

Yesterday, my dad said to have my wits about me on the beach. I said I'd look out for bald eagles. He said, "Bald eagles, bald men."

I figured I would never to go to the chiropractor again because of the history of White supremacy and necks. But somehow, at home, I've started to visit a White chiropractor. His head is shaved clean, shiny, and his patients avert their gazes in the hallway, as I do to their bumper stickers. We live in the same county, on different planets. Each time I lay down for him to crack my neck, I wonder if my subconscious has me engaging in some kind of colonial S&M. Leaving myself at the mercy of his hands as a weekly gamble. Like I'm running my hands along the edge of something. Taking the temperature of the water between us. Myself the canary.

An eagle coasts down to the water. Stands. Another comes, the first leaves. Two stand together; their feet descend just like an airplane's wheels. I am hungry. A dog came to say hello and I wasn't scared. A puffy puppy. I am looking for metaphors. I am ovulating.

The collage right now is a lizard eye. Thunderclouds on a mountain.

I remember when a friend from elementary school told me her mother was pregnant, I was convinced she was going to give birth to a lizard. Or maybe that's a story my mom told me about herself when she was pregnant. When the cause of "infertility" on your medical chart reads "male problem," everything can feel very lizard baby, very *Gattaca*. And yet the goal, the hope, is to put your body in its most mortal posture. We should be so lucky if the result of our *Gattaca* is a Maya Hawke.

The first time I got pregnant and we realized the bleeding was not going to stop, we walked toward the parking lot from our apartment at four in the morning. A beautiful young man asked us for money. There was a high tension-wire vibe that night, like a Halle Berry plot or the beginning of that Stevie Wonder song. "It's my birthday," he said.

We ended up in a hospital room decorated with an undersea theme, as a television played an infomercial for an air fryer. That ultrasound was the worst pain of my life, but we

all took a moment to laugh about the implausibility of the cake pops.

When we got home, I missed the hospital, so I started watching *Grey's Anatomy*. It didn't occur to me that this could be grief until season fifteen.

Here I am in the sauna-style upstairs of a beachside pizzeria. It's fun to see how the couple who owns the place has changed—not much, just more gray, a bit of belly on the dad and, just, I don't know. More season in the face of the mom. Their son must be a senior in high school.

I had feelings about two tall, loud men joining me in my empty sauna of a room, but one has purple hair, so I relax. The man with purple hair walks into a chime.

The mother narrates the pizza she's making to her child— "feta." At least, I think the child is hers. She is unmistakably a rearrangement of her parents' features, which I find emotionally overwhelming. An expression of all the time that has passed since I was last here, this tiny collision of blue eyes and freckles. Her mother says, "Sweetheart." The tiny doppelganger wears a velvet long-sleeved shirt and shorts. The phone rings.

When she brings me my pizza, the mother is the first and only person in Homer who says, "I remember you."

There is an undercurrent of seagull screams. An eagle flaps, coasts, lands. Men wait for their blue pear pie, which I

remember well. The water on shore is curvy; one circle has the coffee stain quality, like the fragment of Toomer's circle, or an alien talking.

I forget what's a thing to say.

At the beach parking lot, a Black lady with short hair and an open expression pulls into a space facing the glacier.

On the drive back to Anchorage, I pass mountains carved out of exquisitely dark gradations of gray. There is a dude bird-calling through a giant animal horn at a scenic lookout at a lake. I stop to record him covertly with my phone, and as if in response, though he couldn't possibly see me, he runs back to his car, swerves into the oncoming traffic lane, and turns left from the right lane to get on the highway. I cannot fathom what his role is here.

I drive past a small beach area. Someone looks to be crouching near a large piece of driftwood. It's so curvy, I look again. It's a beached whale. It looks slashed, rotting. The color of red clay. On the podcast leaving town, Kiese Laymon talks about choices.

Anchorage has the exhausted quality of a place that spends most of the year in darkness and isn't terribly concerned with making itself up once the sun is out. A very fit woman with a very exposed midriff and red lipstick stands with a tan dude in sunglasses. They look to be in an utterly different film from the family getting out of a Tacoma truck beside them. From that car emerges a White guy with waist-long dreads. Mom is holding a sixish-looking child with the ferocious affection of a bear. Robin Coste Lewis writes of a cow they must wait for in India to give birth on a road. The cow wants to run away, her baby is dead, but everyone has decided: she has to see it first.

I'm trying to slow down my exit from this place—I'm anxious to go but also have five hours' wait before my flight. I could have stopped for a hike. The coastal drive is unbelievable. A pink wash of sea. Every turn around these cliffs, a world. There seemed to be another glacier en route. Björk's "Possibly Maybe" played as I drove, and I wanted to record how perfectly it framed the moment, but I knew I would die if I reached for my phone.

I'm writing in a parking lot. I wonder about the lives of the people who shop at this grocery store.

A Black man in the most comfortable, stylish, gray-blue sweatshirt and gray sweatpants saunters to the door. A little White girl doesn't hold it open for him. I hope his house has a lot of windows.

Acknowledgments

Thank you to Youmna Chlala and Chris Fischbach for inviting me to do this project. It was a strange and beautiful prompt, reenacting Georges Perec's *An Attempt at Exhausting a Place in Paris* in Alaska, and I wouldn't have done it otherwise. Thank you, too, to Spatial Species series coeditor Ken Chen. I was so happy to get the chance to work with Anitra Budd, who offered a careful critique of the book. And thanks to Annemarie Eayrs and Kellie M. Hultgren for such thoughtful copyediting. So many thanks to the Coffee House team: Carla Valadez, Erika Stevens, Carol Mack, Lizzie Davis, Marit Swanson, and Daley Farr—you have been so gracious through an impossible year. And thank you, Mika Albornoz, for this dreamy cover.

Thank you to K, who invited me to spend my first summer in Alaska. I would not have thought myself capable of any number of weeks without running water. The way you witness and adventure into this world gives me hope for the rest of us. Thank you to all of my exes, and my exes' exes, and your partners, but not in an Ariana Grande way, I don't think. Thank you to the people of Homer, for withstanding

my awkwardness multiple years and decades in a row. Thank you to the Kachemak Bay Writers' Conference. I first came to you as a mere babe, and I found friendship and advice there that shaped the course of my writing life. Thank you to all of the moose, bald eagles, that one owl, and possibly some bear, for keeping your distance. Thank you to Jeremy Mulligan: we grow as writers together, even though I am a horrible correspondent; you are one of the most diligent writers I've ever witnessed, and I am in constant admiration of you.

Thank you to Hannah Ensor for meeting me inside that Richard Serra and for telling me this book is, in fact, something I can share with other people, we'll see. To my parents, as always. To my great-uncle Jimmy for the queer cross-generational conversation. To Beth Alvarado, Debbie Weingarten, Arianne Zwartjes, Riley Beck Iosca, Lisa O'Neill, Logan Byers, Guardian of the Heart, Gabrielle Civil, Ruth Curry, Tisa Bryant, Samiya Bashir, Alea Adigweme, and NonfictioNOW, for the writerly community, for Ekphrasis and the Black Female Gaze, for witnessing geysers together, letting me drive stick shift through the Golden Circle, for holding us all to a higher standard. Thank you to my Black and Ekphrastic class and my summer workshop class at Chatham, our conversations sparked so many of the ideas in this book. Thank you to my Auntie Katherine, I love

you forever. And Aunt Cora Mae, dancing somewhere, I miss you. Thank you to my Ilona, this book tried to imagine what it might be like if you came along, and here you are.

Thank you to those of you whose art, from a distance, helped shape the questions posed here—Lorna Simpson, Robin Coste Lewis, Wendy S. Walters, Renee Gladman, Camille Dungy, Fred Moten, Saidiya Hartman, Jean Toomer. And to Björk, Chance the Rapper, and all the other musicians whose work kept me company on this weird trip.

Coffee House Press began as a small letterpress operation in 1972 and has grown into an internationally renowned nonprofit publisher of literary fiction, essay, poetry, and other work that doesn't fit neatly into genre categories.

Coffee House is both a publisher and an arts organization. Through our *Books in Action* program and publications, we've become interdisciplinary collaborators and incubators for new work and audience experiences. Our vision for the future is one where a publisher is a catalyst and connector.

LITERATURE
is not the same thing as
PUBLISHING

Funder Acknowledgments

Coffee House Press is an internationally renowned independent book publisher and arts nonprofit based in Minneapolis, MN; through its literary publications and *Books in Action* program, Coffee House acts as a catalyst and connector—between authors and readers, ideas and resources, creativity and community, inspiration and action.

Coffee House Press books are made possible through the generous support of grants and donations from corporations, state and federal grant programs, family foundations, and the many individuals who believe in the transformational power of literature. This activity is made possible by the voters of Minnesota through a Minnesota State Arts Board Operating Support grant, thanks to the legislative appropriation from the Arts and Cultural Heritage Fund. Coffee House also receives major operating support from the Amazon Literary Partnership, Jerome Foundation, McKnight Foundation, Target Foundation, and the National Endowment for the Arts (NEA). To find out more about how NEA grants impact individuals and communities, visit www.arts.gov.

Coffee House Press receives additional support from Bookmobile; Dorsey & Whitney LLP; Fredrikson & Byron, P.A.; Kenneth Koch Literary Estate; the Matching Grant Program Fund of the Minneapolis Foundation; Mr. Pancks' Fund in memory of Graham Kimpton; the Schwab Charitable Fund; and the U.S. Bank Foundation.

The Publisher's Circle of Coffee House Press

Publisher's Circle members make significant contributions to Coffee House Press's annual giving campaign. Understanding that a strong financial base is necessary for the press to meet the challenges and opportunities that arise each year, this group plays a crucial part in the success of Coffee House's mission.

Recent Publisher's Circle members include many anonymous donors, Patricia A. Beithon, Anitra Budd, Andrew Brantingham, Dave & Kelli Cloutier, Mary Ebert & Paul Stembler, Jocelyn Hale & Glenn Miller, the Rehael Fund-Roger Hale/Nor Hall of the Minneapolis Foundation, Randy Hartten & Ron Lotz, Dylan Hicks & Nina Hale, William Hardacker, Kenneth & Susan Kahn, Stephen & Isabel Keating, the Kenneth Koch Literary Estate, Cinda Kornblum, Jennifer Kwon Dobbs & Stefan Liess, the Lambert Family Foundation, the Lenfestey Family Foundation, Sarah Lutman & Rob Rudolph, the Carol & Aaron Mack Charitable Fund of the Minneapolis Foundation, Gillian McCain, Malcolm S. McDermid & Katie Windle, Mary & Malcolm McDermid, Daniel N. Smith III & Maureen Millea Smith, Peter Nelson & Jennifer Swenson, Enrique & Jennifer Olivarez, Alan Polsky, Robin Preble, Jeffrey Sugerman & Sarah Schultz, Nan G. Swid, Grant Wood, and Margaret Wurtele.

For more information about the Publisher's Circle and
other ways to support Coffee House Press books, authors, and
activities, please visit www.coffeehousepress.org/pages/donate
or contact us at info@coffeehousepress.org.

About the Spatial Species Series
Youmna Chlala and Ken Chen, series editors

The Spatial Species series investigates the ways we activate space through language. How do we observe where we are? How do we mark and name our behavior in space? How does a space occur as a midpoint between memory/history and future speculations? We pass over monuments, tourist spots, and public squares in favor of serendipity and détournement: non-spaces, edges, diasporic traces, and borders. Georges Perec revealed the value of how we relate to the infra-ordinaire. Such intimate journeying requires experiments in language and genre, moving travelogue, fiction, or memoir into something closer to eating, drinking, and dreaming.

Youmna Chlala is a writer and artist born in Beirut and based in New York. She is the author of the poetry collection *The Paper Camera*. She has published in *BOMB*, *Guernica*, *Aster(ix)*, *Bespoke*, and *Prairie Schooner*, for which she won an O. Henry Award. Her artwork has been exhibited at the Bienal de São Paulo, Lofoten International Art Festival, and Performa Biennial, as well as the Hayward Gallery, the Drawing Center, Art in General, Art Dubai Projects, and Kunsthal Charlottenborg.

Ken Chen won the Yale Younger Poets Prize for his book *Juvenilia*, which was selected by Louise Glück. From 2008 to 2019 he served as the executive director of the Asian American Writers' Workshop. He is attempting to rescue his father from the underworld, a site that serves as an archive for all that has been destroyed by colonialism.

Aisha Sabatini Sloan was born and raised in Los Angeles. Her writing about race and current events is often coupled with analysis of art, film, and pop culture. She studied English literature at Carleton College and went on to earn an MA in cultural studies and studio art from the Gallatin School of Individualized Study at NYU and an MFA in creative nonfiction from the University of Arizona. She is the author of the essay collections *The Fluency of Light: Coming of Age in a Theater of Black and White* and *Dreaming of Ramadi* in Detroit. With her father, she is the author of *Captioning the Archives: A Conversation in Photography and Text.* She is a recipient of the 2018 CLMP Firecracker Award for Creative Nonfiction and a 2020 National Endowment for the Arts Literature Fellowship. She teaches creative writing at the University of Michigan.

Borealis was designed by Mika Albornoz.
Text is set in Spectral.